The Wonder of Boys

the world through the eyes of boys

· Karen Henrich ·

CUMBERLAND HOUSE

NASHVILLE, TENNESSEE

THE WONDER OF BOYS
PUBLISHED BY CUMBERLAND HOUSE PUBLISHING
431 Harding Industrial Drive
Nashville, Tennessee 37211

Cover design: James Duncan Creative
Book design: Mary Sanford

ISBN-13: 978-1-58182-612-8
ISBN-10: 1-58182-612-5

Printed in Canada
1 2 3 4 5 6 7—13 12 11 10 09 08 07

I dedicate this book to my three boys; you fill my world with wonder and for that I am forever grateful.

Acknowledgments

Having been raised in a family with one sister, I never thought that when it came time to raise my own family, it would be filled with boys. But that being said, it is with gratitude that I thank the boys in my life (especially our sons Chris and Mason) for teaching me so many simple truths about life that I would not have otherwise known. . . . For example, it is okay to bounce the ball in the house as it does not *always* break something, pillow forts are sometimes made with the sole intention of tearing them down, and watching sports on TV is *never* the same as being at the live game. Scott, our family, and our friends that are truly family to us as well, I appreciate you all holding up my dreams. My publisher, Ron Pitkin, Mary Sanford, and Michelle Nicolai, many thanks to each of you for your enthusiasm and commitment to bringing this book to share with others.

It was once said, "Snips and snails and puppy dog tails, that's what little boys are made of." Capturing the world of a boy from behind the lens, I see boys as actually being made of curiosity, energy, and determination. With their contagious spirit boys teach us to celebrate every opportunity, whether that be the chance to find a small mud puddle to jump in after a rainstorm or the opportunity to throw their arms and thus their hearts around us.

Boys from a very young age know who they are and it is with that passion and conviction that they tackle the world. A boy celebrates finding a frog in a pond or hearing the ice cream truck on a summer day just as much as getting a hug and kiss at the end of the day.

We all grow up too fast (no matter how old we currently are). Although we cannot change where we are at this moment nor where are going in the next moment, we can take the opportunity to once again, through the eyes of the boys in the following images, see the world anew.

As you see a glimpse of a boy's soul, through his expression, it is my wish that you will take a moment to share in their wonderment and their world. Through one or many of these images, you may come to look at your world a bit differently.

Enjoy the journey.

I believe that all children are full of the same wonder of the world. A child's spirit does not hide, even in illness. To that end, I have started a non-profit foundation, Moment by Moment, which captures images of terminally ill children. A cadre of professional photographers donate their time to work with the foundation to capture these precious and fleeting images. Families of these children receive a photography session with one of these professional photographers, a set of black and white matted images, and a DVD of the session, all at no cost to the family.

A percentage of the proceeds from this book will go directly to the Moment by Moment Foundation to ensure that as many families as possible receive this gift.

The Wonder of Boys

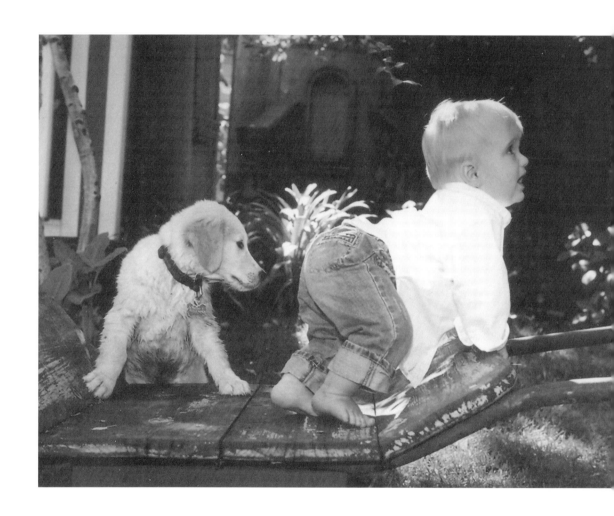

Snips and snails and puppy dog tails, that's what little boys are made of.

To know the beauty of clouds and wishes and wagons filled with dreams, we must see through the eyes of a child.

[ANONYMOUS]

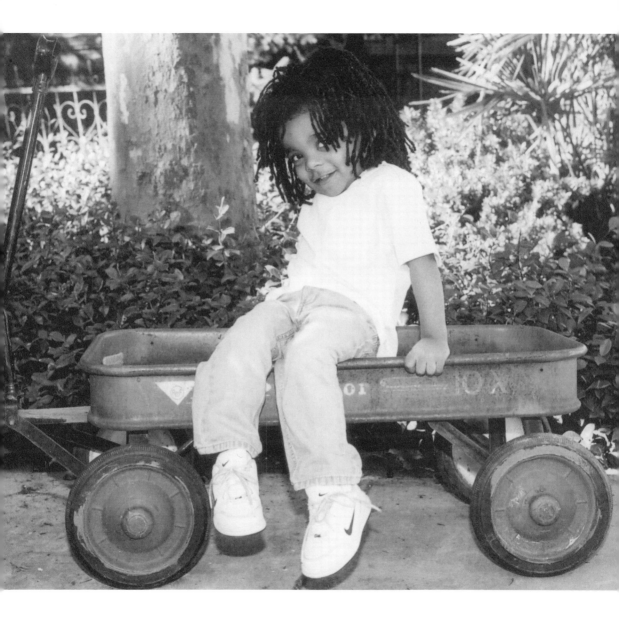

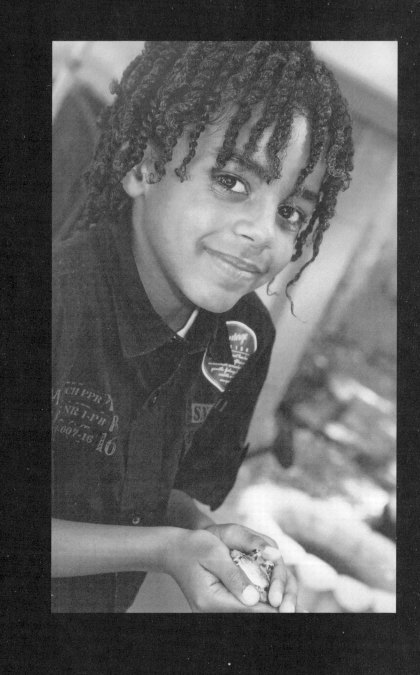

A boy is truth with dirt on its face. Beauty with a cut on its finger. Wisdom with bubble gum in its hair and the hope of the future with a frog in its pocket.

[ALAN BECK]

My father didn't tell me how to live;
he lived, and let me watch him do it.

[CLARENCE BUDINGTON KELLAND]

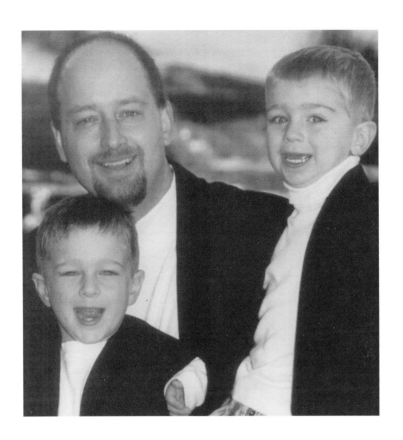

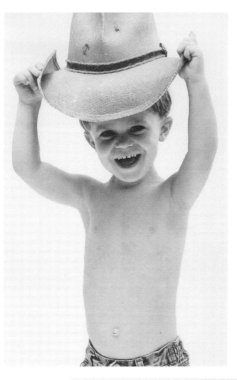
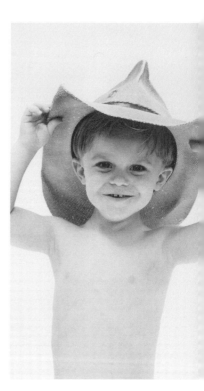
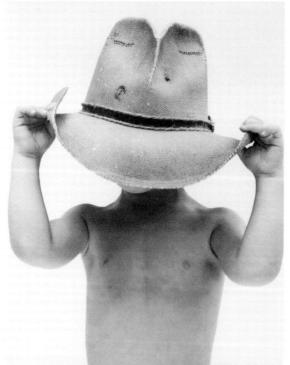

I like my boy . . . and his utter inability to conceive why I should not leave all of my nonsense, business, and writing and come to tie up his toy horse.

[RALPH WALDO EMERSON]

There comes a time in every rightly constructed boy's life when he has a raging desire to go somewhere and dig for hidden treasure.

[MARK TWAIN]

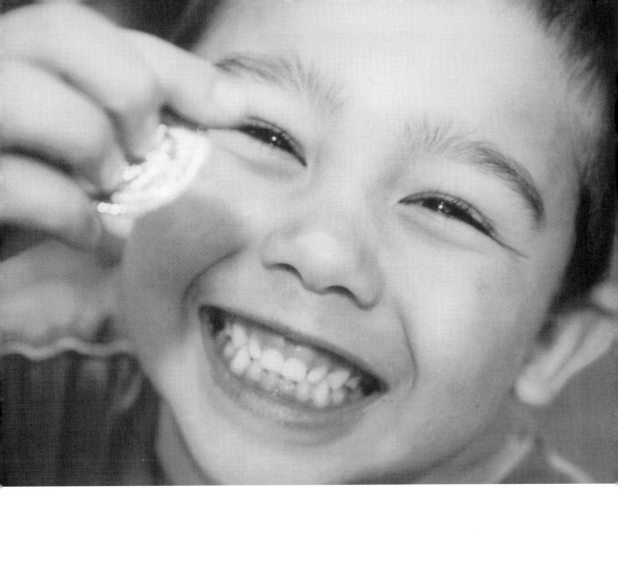

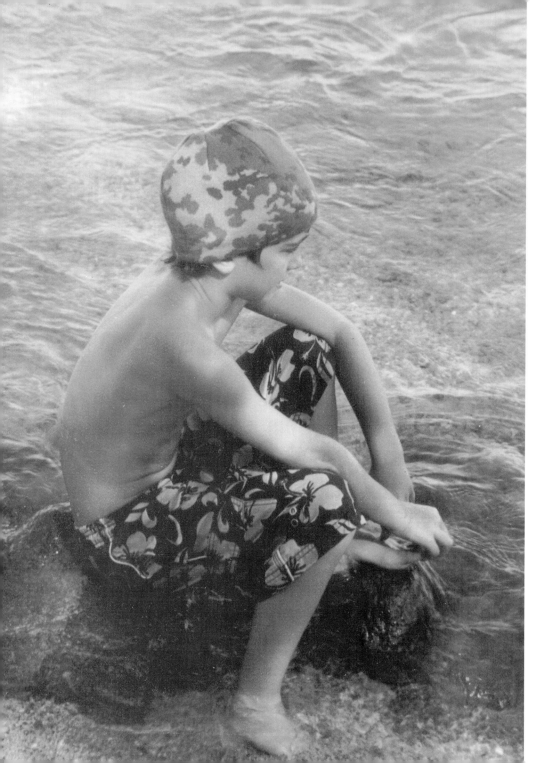

It is easier to build strong children than to repair broken men.

[FREDERICK DOUGLASS]

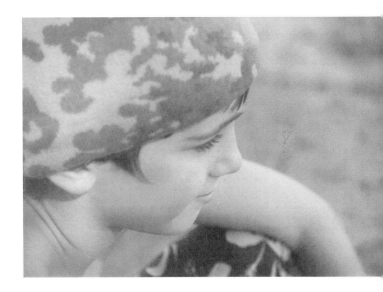

Just when the day seemed really boring and yucky, I heard the music of the ice-cream truck.

[MAX, AGE 5]

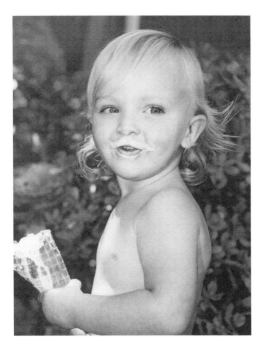
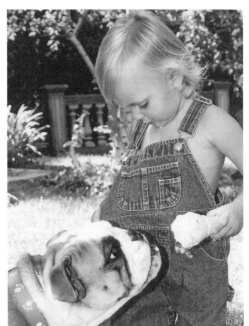
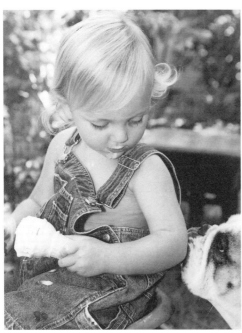
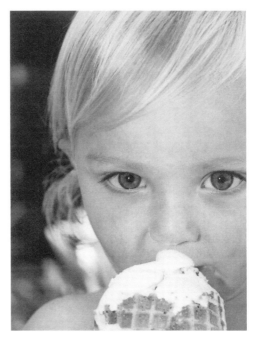

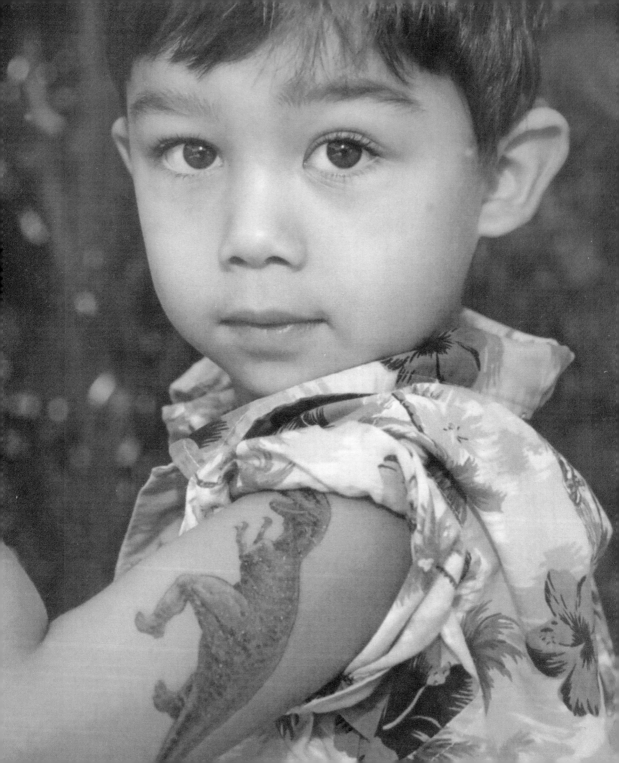

A person's a person, no matter how small.

[DR. SEUSS]

I love it—I love it—the laugh of a child,
Now rippling and gentle,
now merry and mild.

[ISABEL ATHELWOOD]

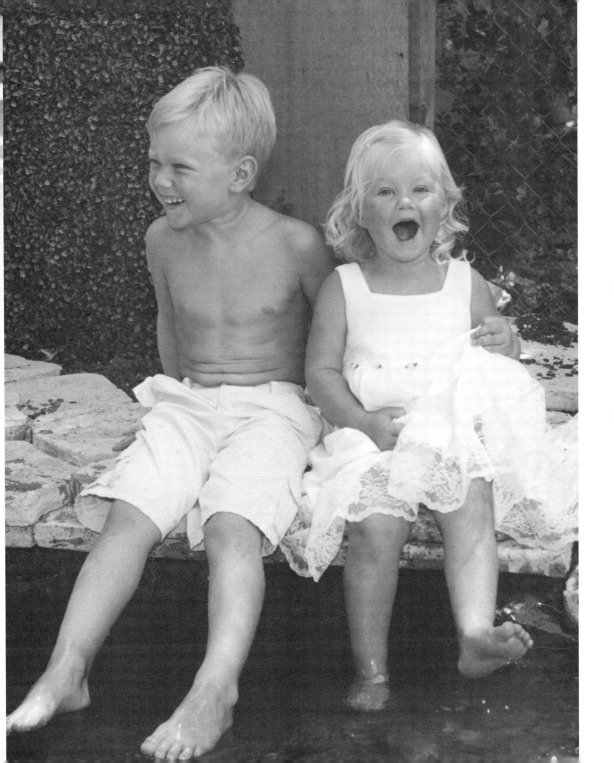

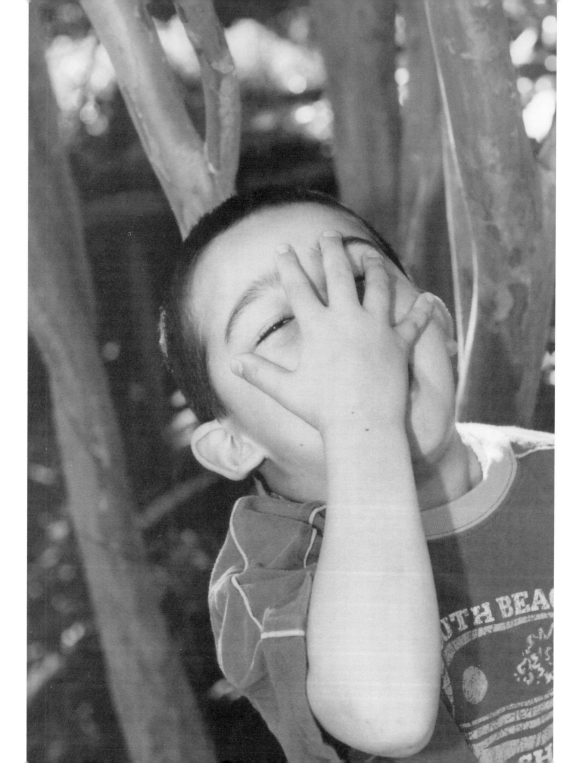

Anyone who thinks the art of
conversation is dead ought to
tell a child to go to bed.

[ROBERT C. GALLAGHER]

The boy who expects every morning to open into a new world finds that today is like yesterday, but he believes tomorrow will be different.

[CHARLES DUDLEY WARNER]

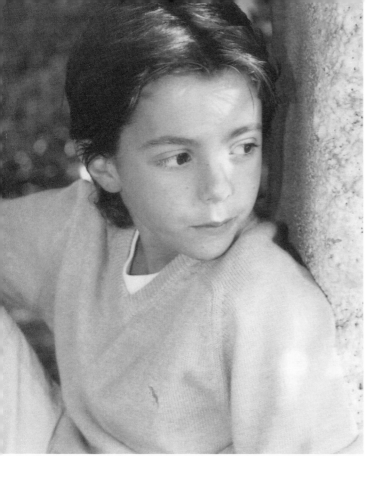

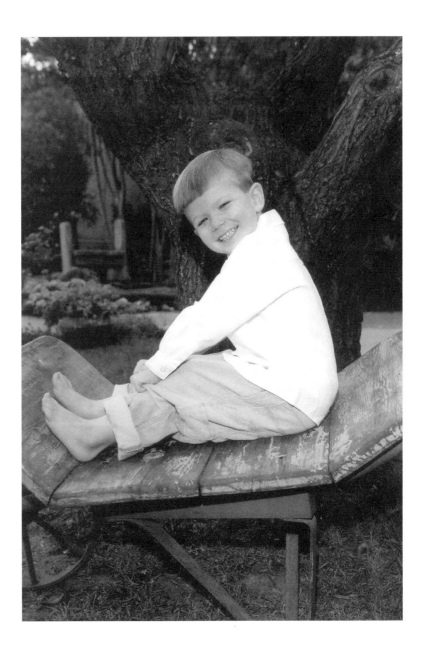

I never want to grow up.

[PETER PAN]

You don't raise heroes, you raise sons. If you treat them like sons, they'll turn out to be heroes even if it's just in your own eyes.

[WALTER M. SCHIRRA SR.]

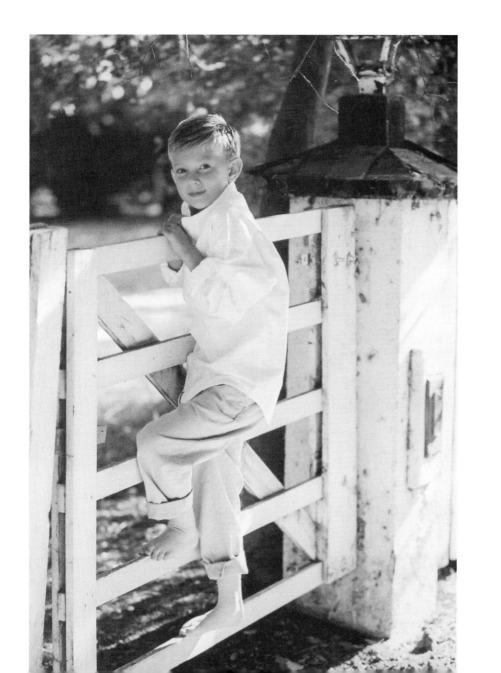

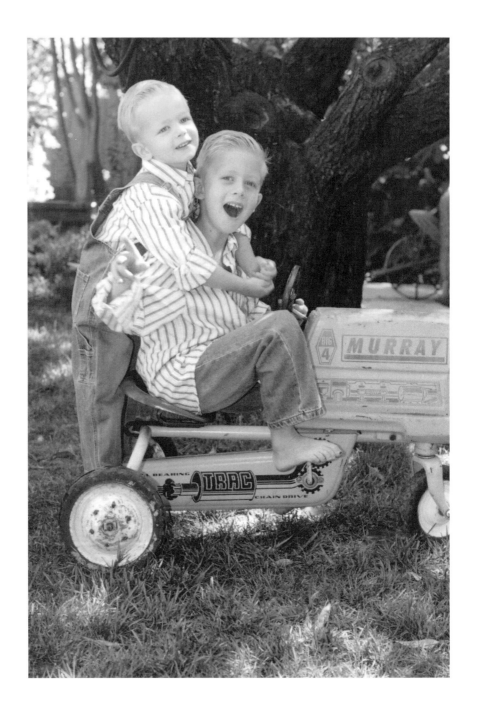

Boys are found everywhere—
on top of,
underneath,
inside of,
climbing on,
swinging from,
running around,
or jumping to.

[ALAN BECK]

Boys will be boys as long as there are no girls in the picture.

[UNKNOWN]

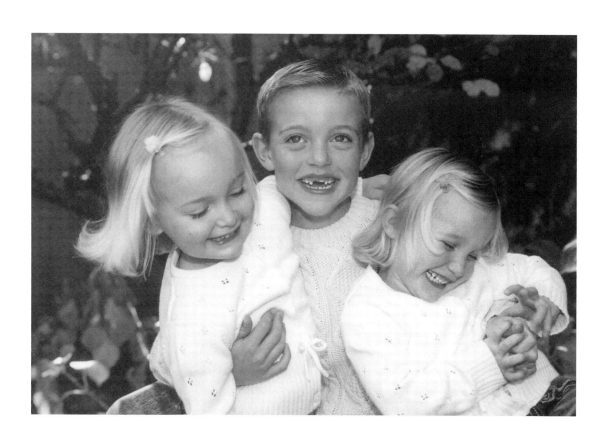

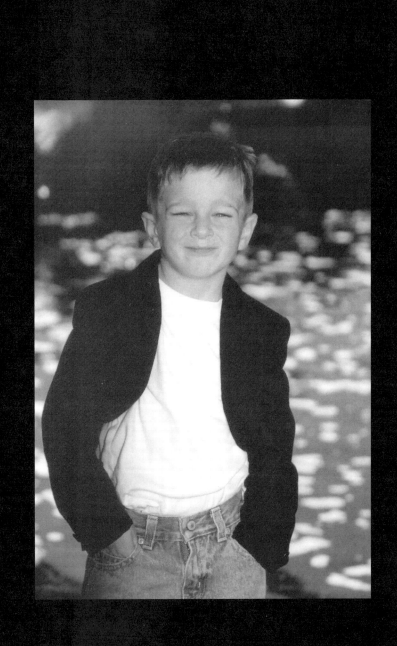

Nobody knows what a boy is worth,
we'll have to wait and see.
But every man in a noble place
a boy used to be.

[UNKNOWN]

Help your brother's boat across
and your own will reach the shore.

[HINDU PROVERB]

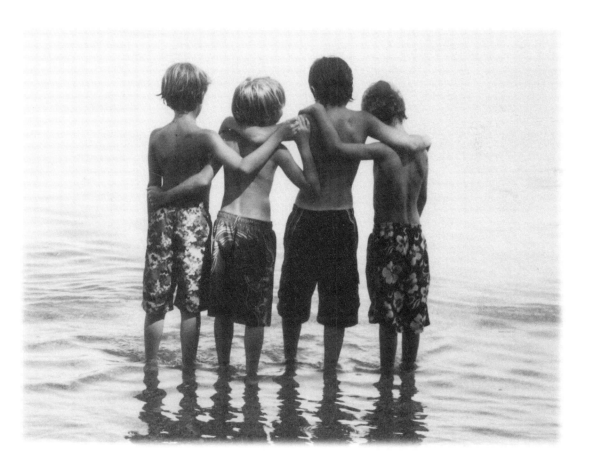

When you teach your son, you teach your son's son.

[THE TALMUD]

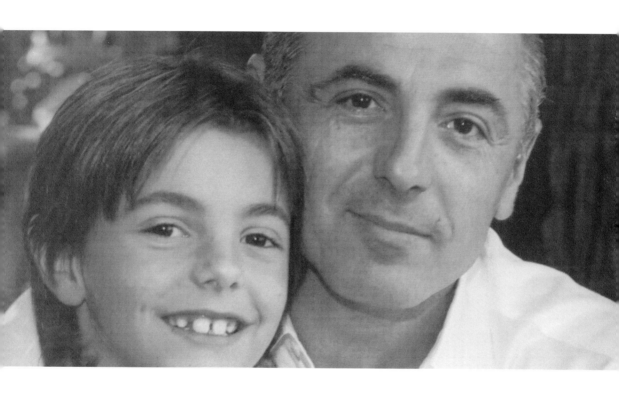

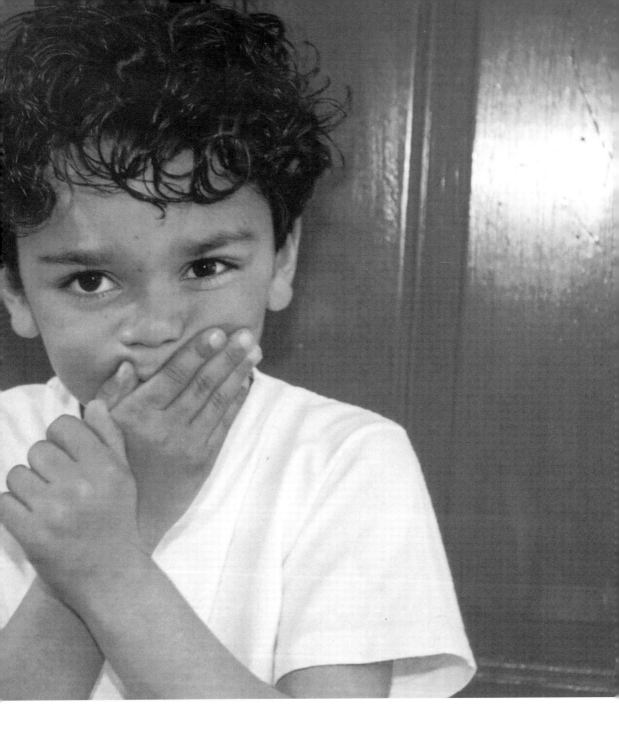

Children seldom misquote.
In fact, they usually repeat word for word
what you shouldn't have said.

[UNKNOWN]

boy *n* A noise with dirt on it.

[NOT YOUR AVERAGE DICTIONARY]

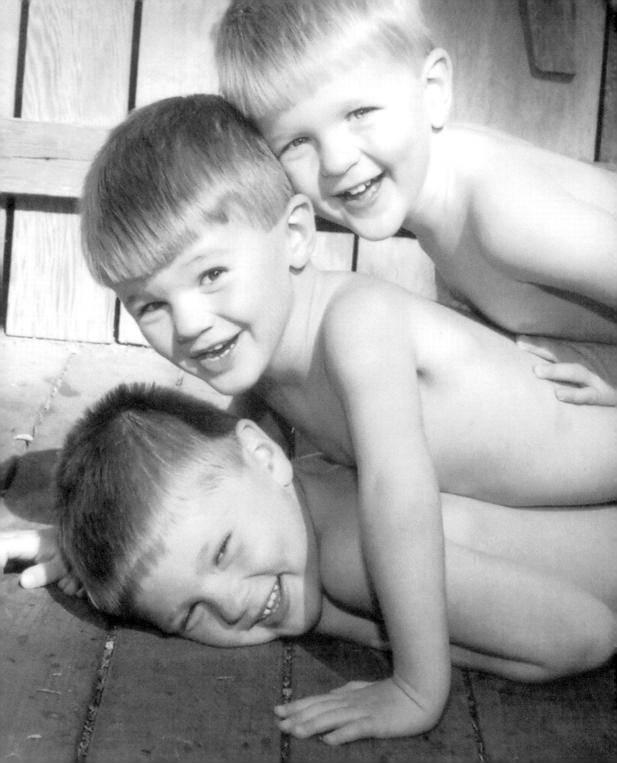

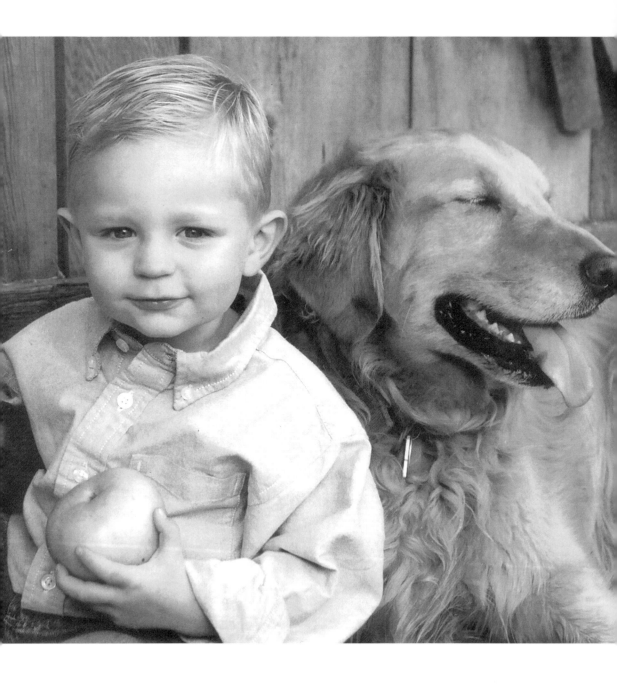

My goal in life is to be as good a person
as my dog already thinks I am.

[UNKNOWN]

There are three ways to get something done:
do it yourself,
employ someone to do it,
or forbid your children from doing it.

[MONTA CRANE]

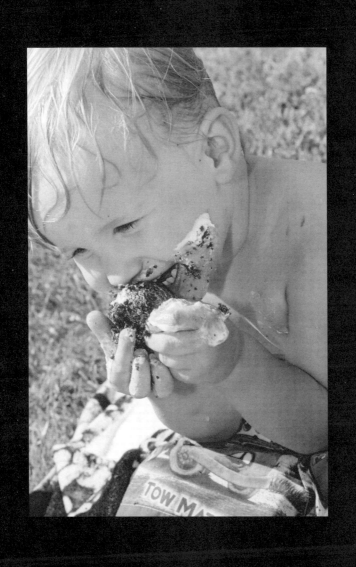

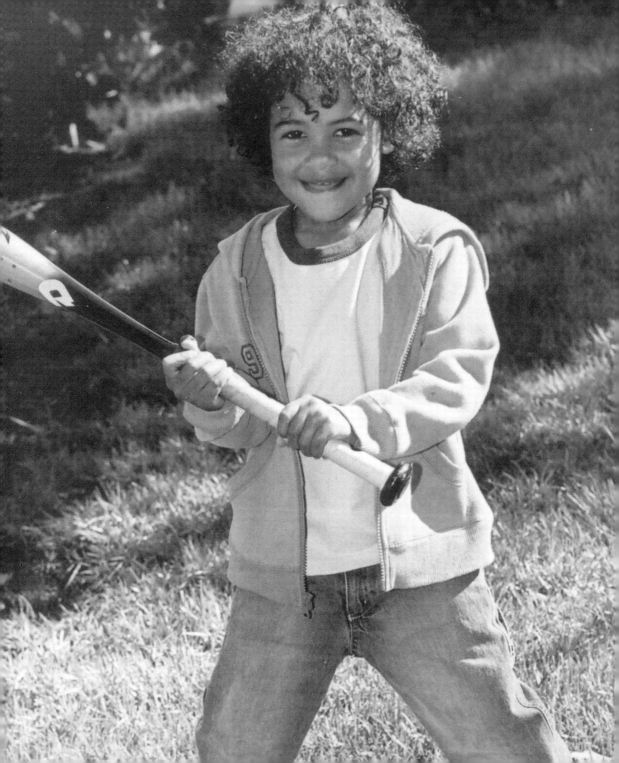

I have heard there are troubles of more than one kind. Some come ahead and some come behind. But I've brought a big bat. I'm all ready, you see. Now my troubles are going to have trouble with me.

[DR. SEUSS]

At times, boys just cannot help but to express their true emotions.

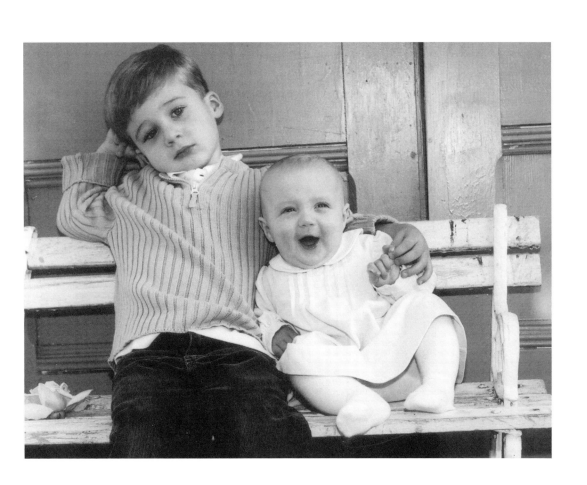

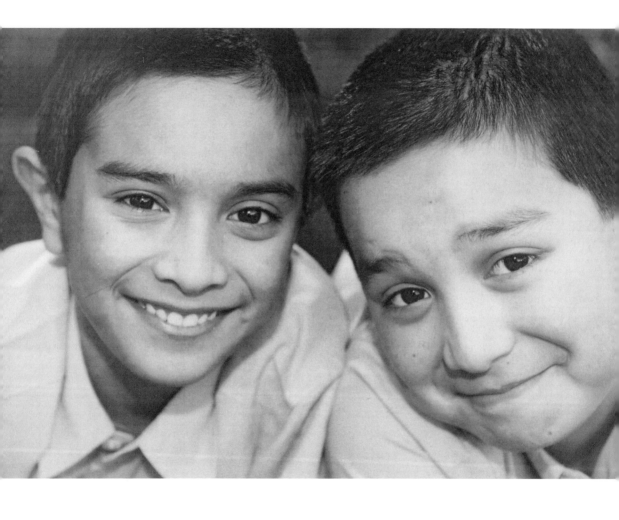

Don't worry that children never listen to you;
worry that they are always watching you.

[ROBERT FULGHUM]

One of the best things in the world to be is a boy; it requires no experience, but needs some practice to be a good one.

[CHARLES DUDLEY WARNER]

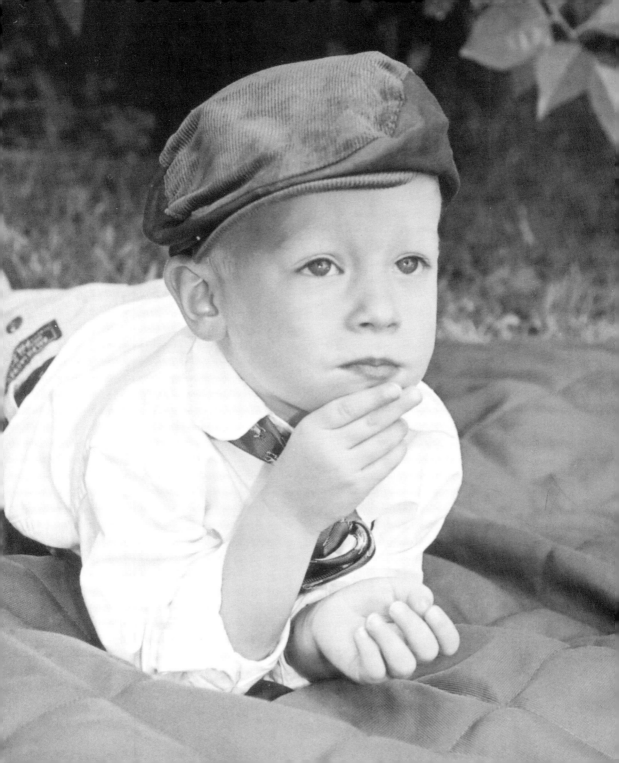

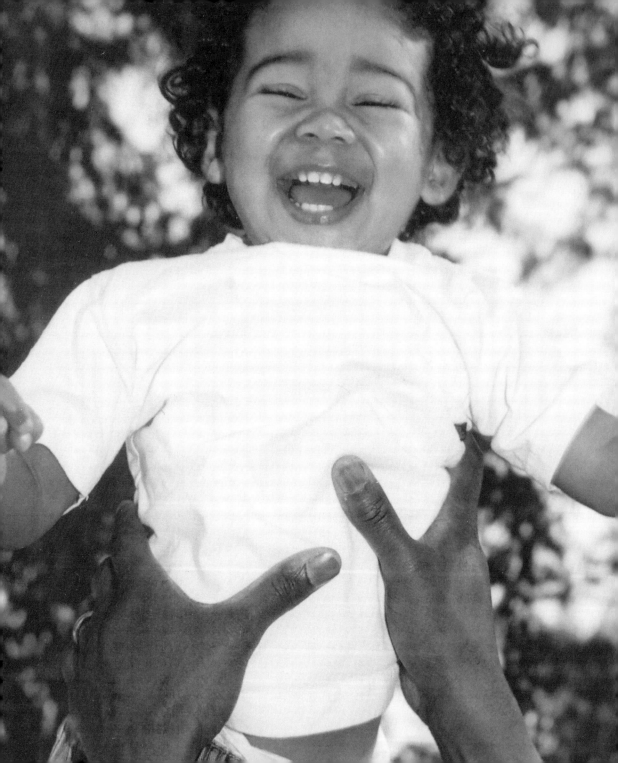

Cheerily, then, my little man,
Live and laugh, as boyhood can!

[JOHN GREENLEAF WHITTIER]

A characteristic of the normal boy is that
he does not act that way very often.

[UNKNOWN]

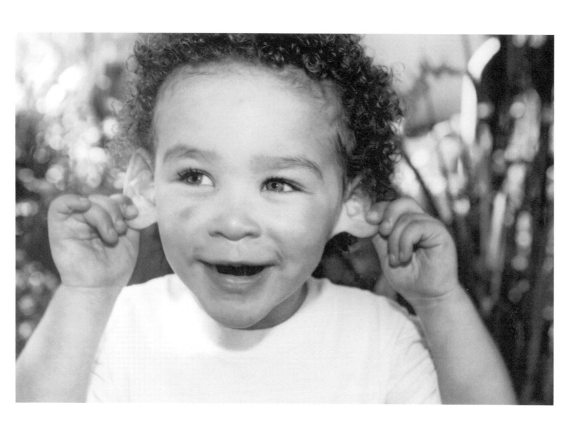

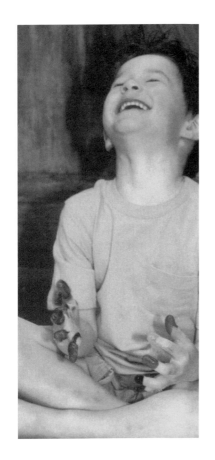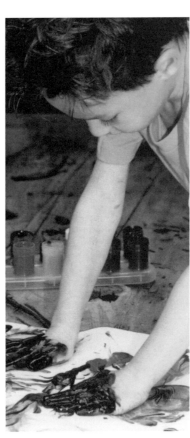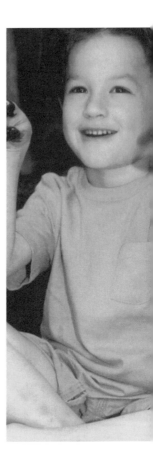

Every child is an artist. The problem is how to remain an artist once we grow up.

All for one and one for all
My brother and my friend
What fun we have
The time we share
Brothers 'til the end.

[UNKNOWN]

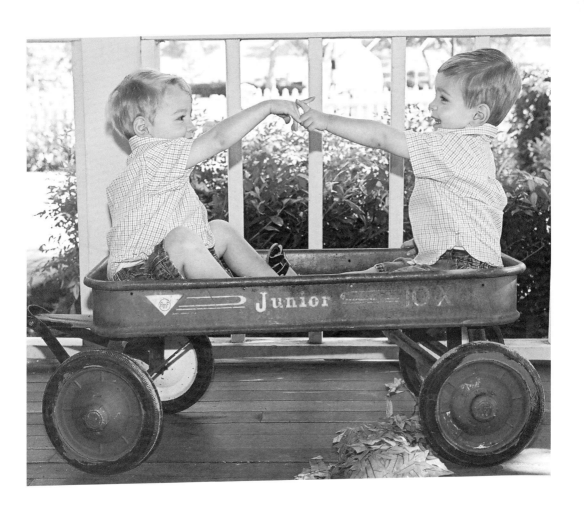

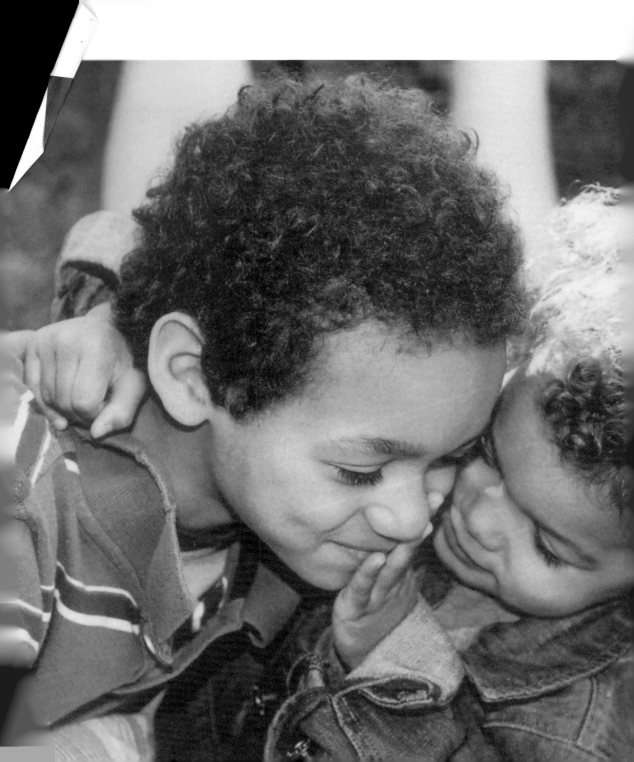

Children have two visions, the inner and the outer.
Of the two, the inner vision is brighter.

[SYLVIA ASHTON-WARNER]

Sometimes being a brother is even better than being a superhero.

[MARC BROWN]

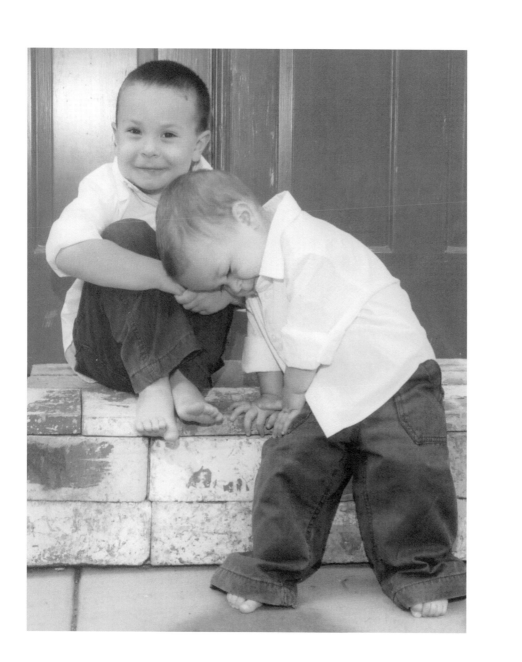

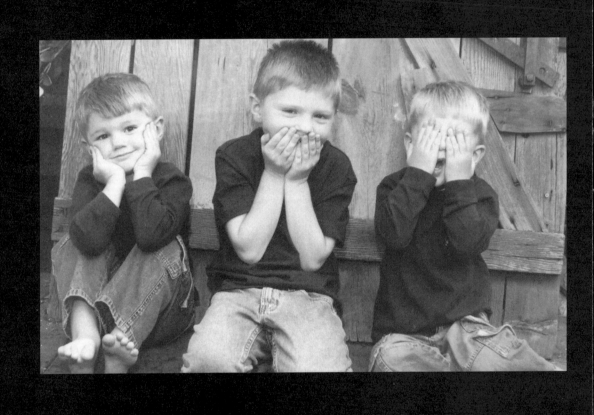

Boys are beyond the range of anyone's sure understanding, at least when they are between the ages of eighteen months and ninety years.

[JAMES THURBER]

My father used to play with my brothers and me in the yard. Mother would come out and say, "You're tearing up the grass." "We're not raising grass," Dad would reply, "we're raising boys."

[HARMON KILLEBREW]

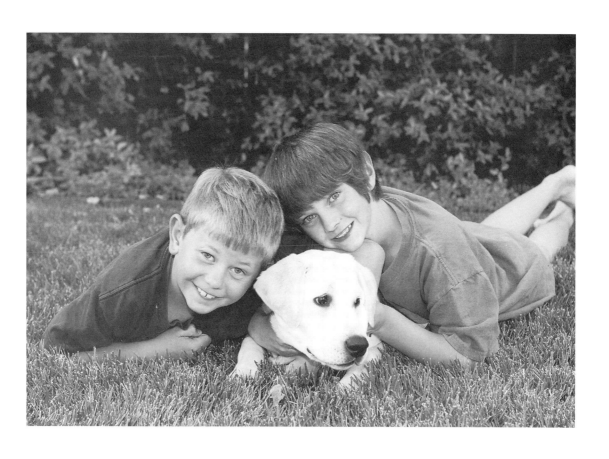

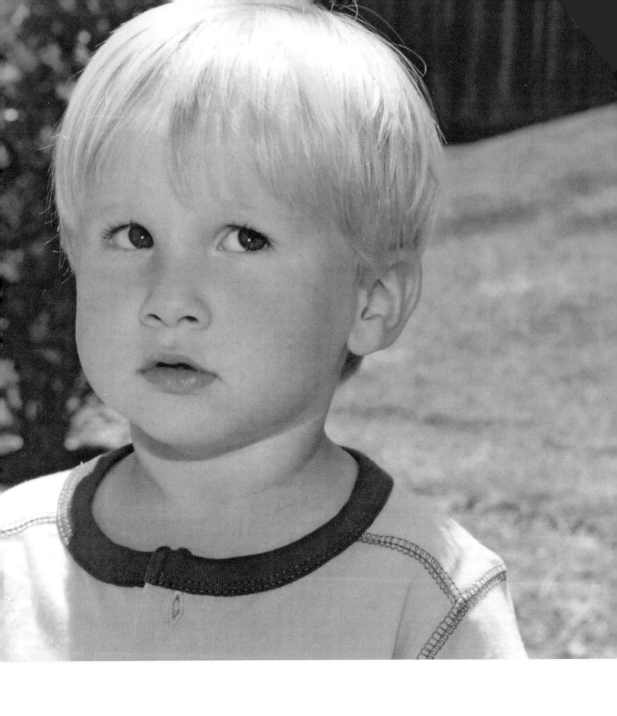

You can learn many things from children. How much patience you have, for instance.

[FRANKLIN P. JONES]

No one knows how it is that with one glance a boy can break through into a girl's heart.

[NANCY THAYER]

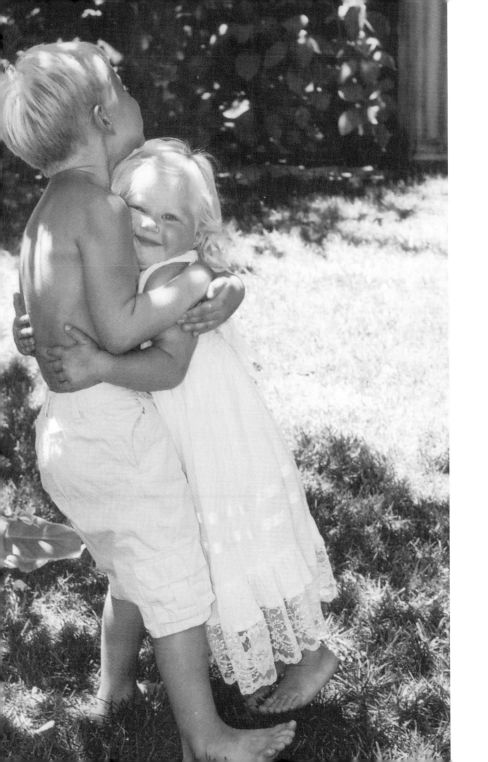

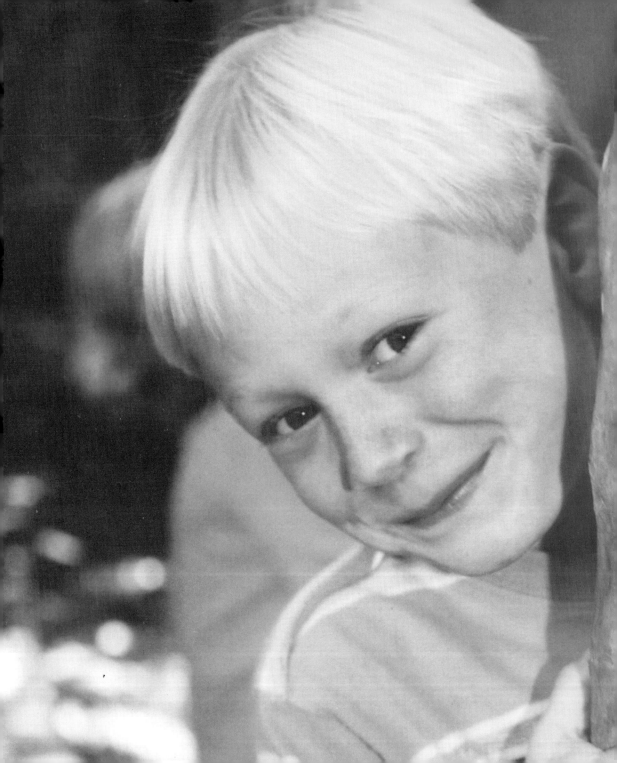

When I grow up I want to be a little boy.

[JOSEPH HELLER]

A boy is a being who gets almost as much fun out of an expensive set of swings as he does out of finding a frog.

[UNKNOWN]

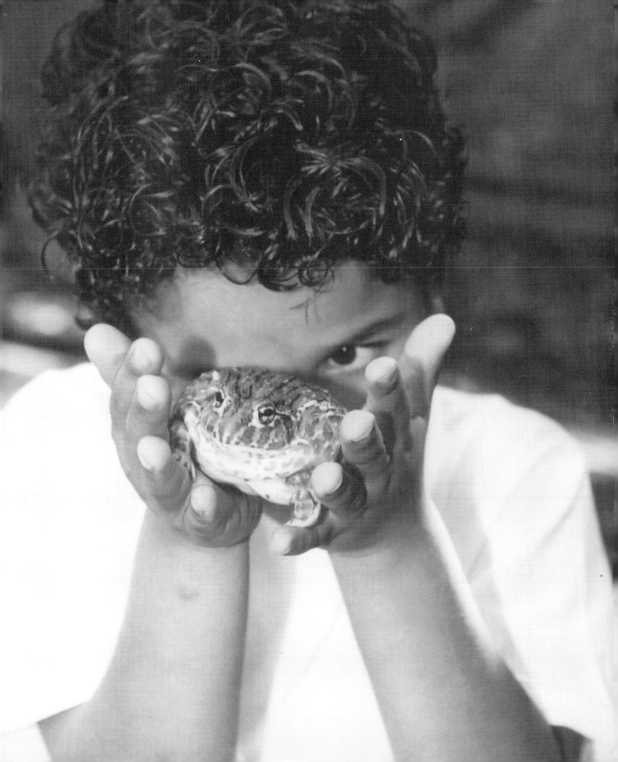

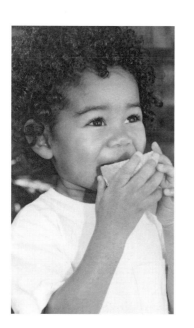

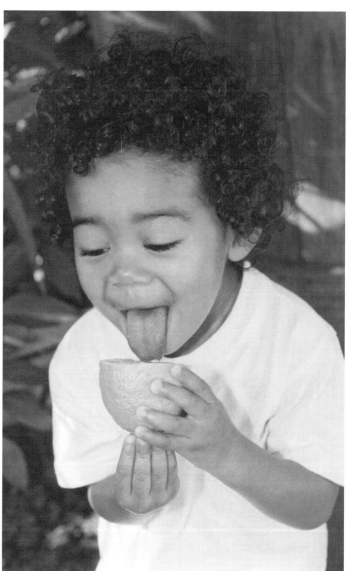

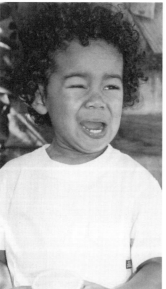

A young child is, indeed, a true scientist, just one big question mark. *What? Why? How?* I never cease to marvel at the recurring miracle of growth, to be fascinated by the mystery and wonder of this brave enthusiasm.

[VICTORIA WAGNER]

Any child can tell you that the sole purpose of a middle name is so he can tell when he is really in trouble.

[DENNIS FAKES]

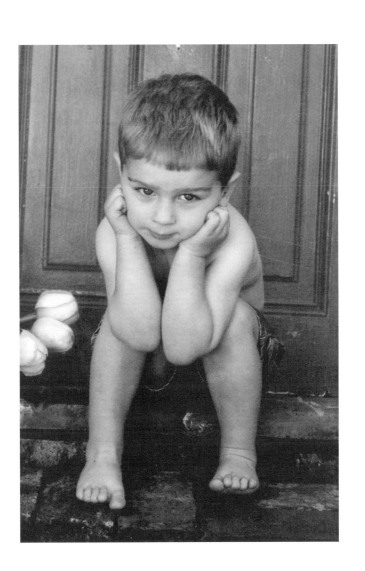

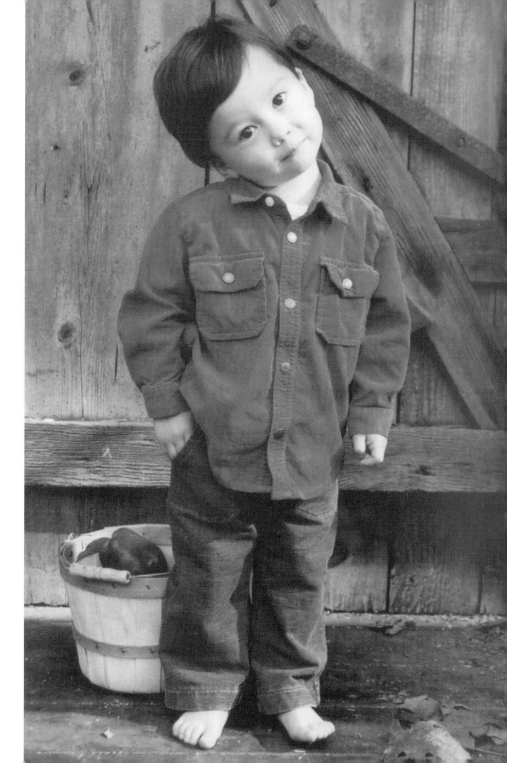

You know that children are growing up
when they start asking questions that
have answers.

[JOHN J. PLOMP]

A boy is a magical creature—you can lock him out of your workshop, but you can't lock him out of your heart. You can get him out of your study, but you can't get him out of your mind.

[ALAN BECK]

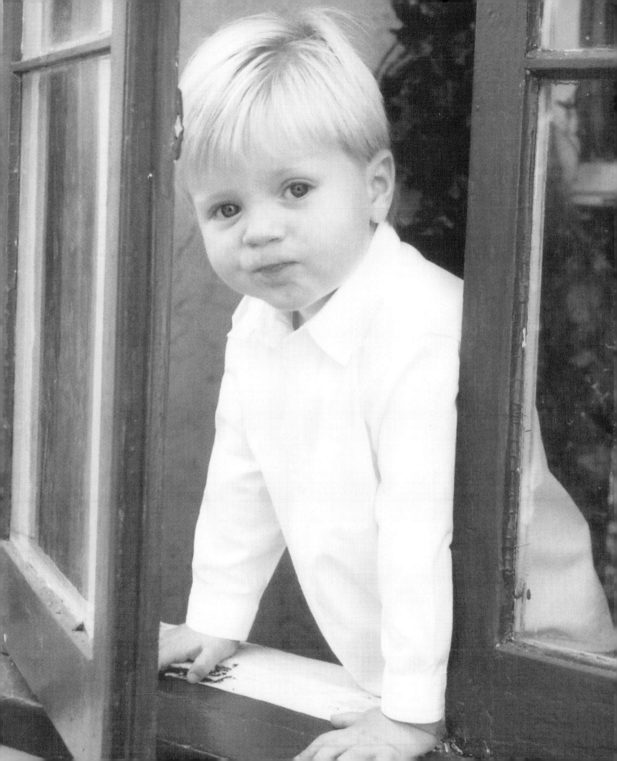

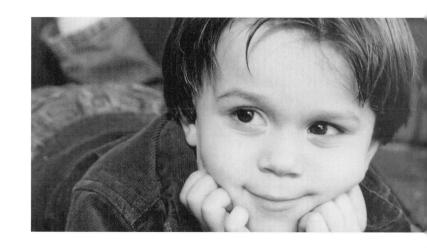

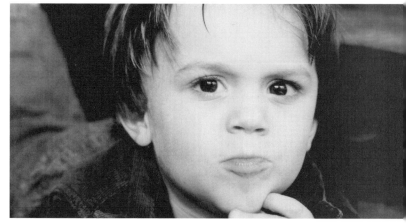

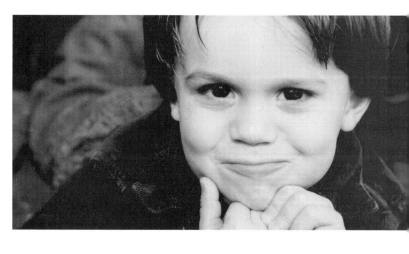

The real menace in dealing with a five-year-old is that in no time at all you begin to sound like a five-year-old.

[JEAN KERR]

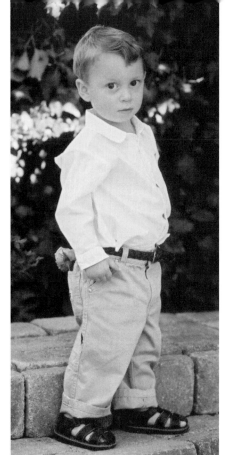
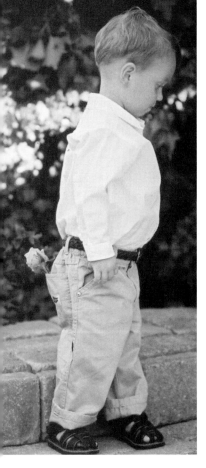
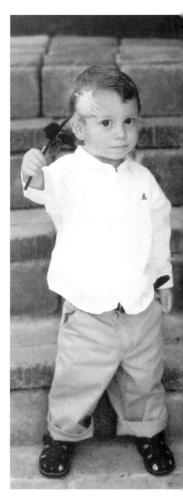

At times, even little boys appreciate the beauty that we often miss.

[UNKNOWN]

To a boy, growing older is mandatory;
growing up is optional.

[UNKNOWN]

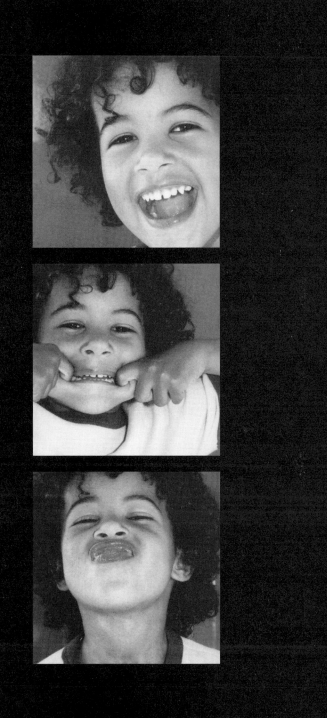

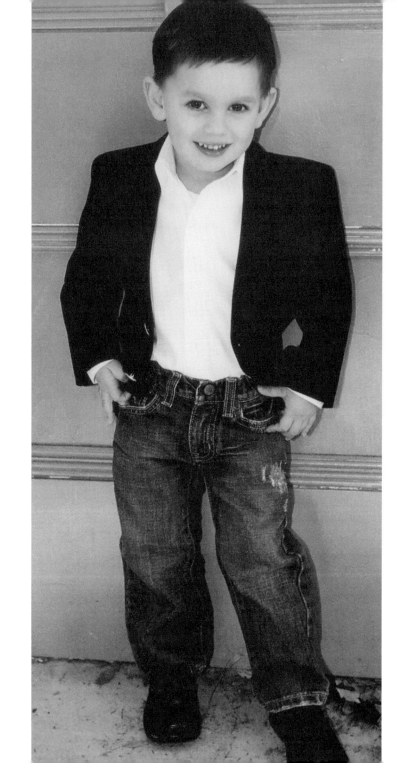

You have to do your

own growing up, no

matter how tall your

grandfather was.

[ABRAHAM LINCOLN]

To become a real boy, you must prove yourself
brave, truthful, and unselfish.

[PINOCCHIO]

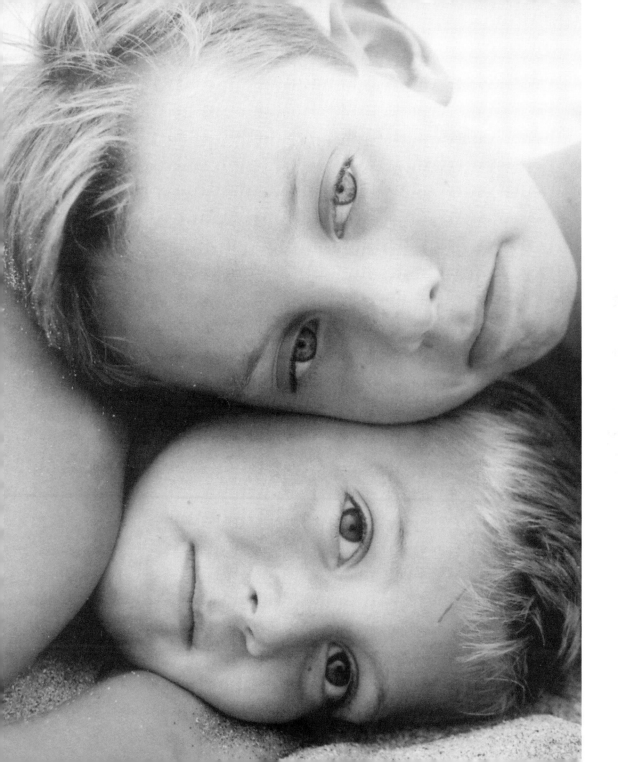

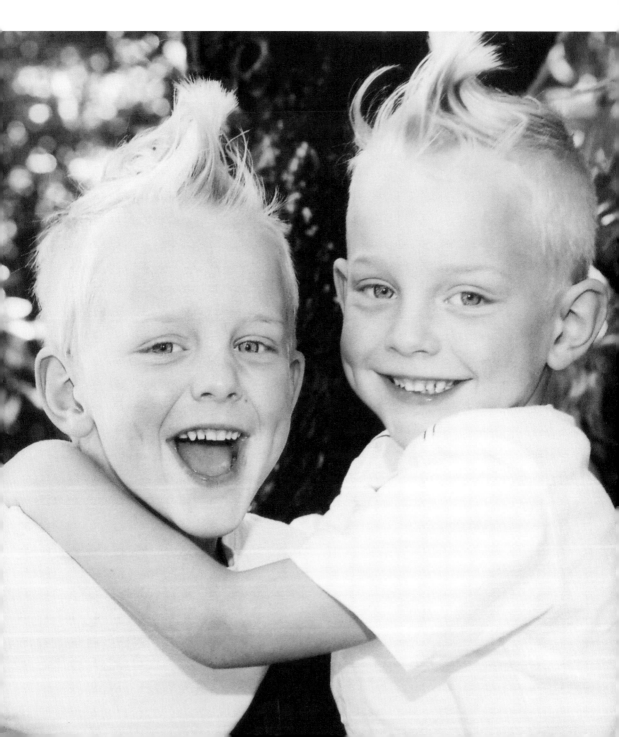

Boys are 90 percent mischief and 10 percent dirt.

I meant what I said and I said what I meant.

[DR. SEUSS]

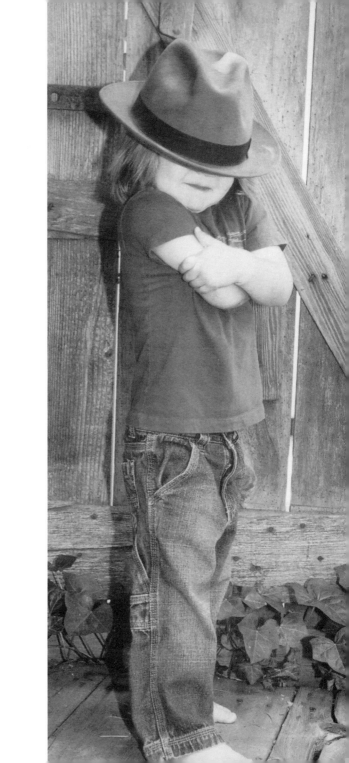

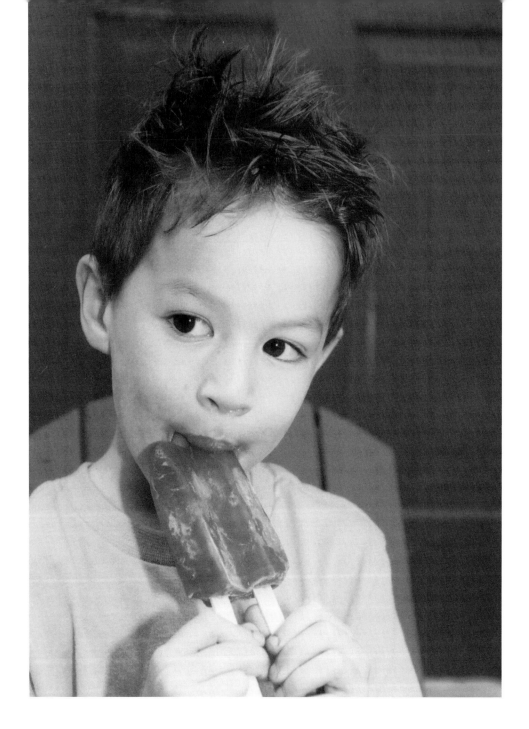

The perfect summer day to a little boy means a scrape on the knee, mud on the face, and a collection of bugs in the garden.

[UNKNOWN]

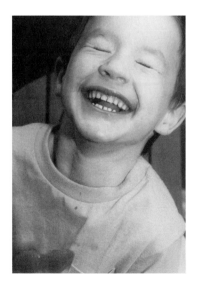
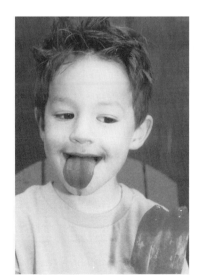

There never has been, nor will there ever be, anything quite so special as the love between a mother and a son.

[UNKNOWN]

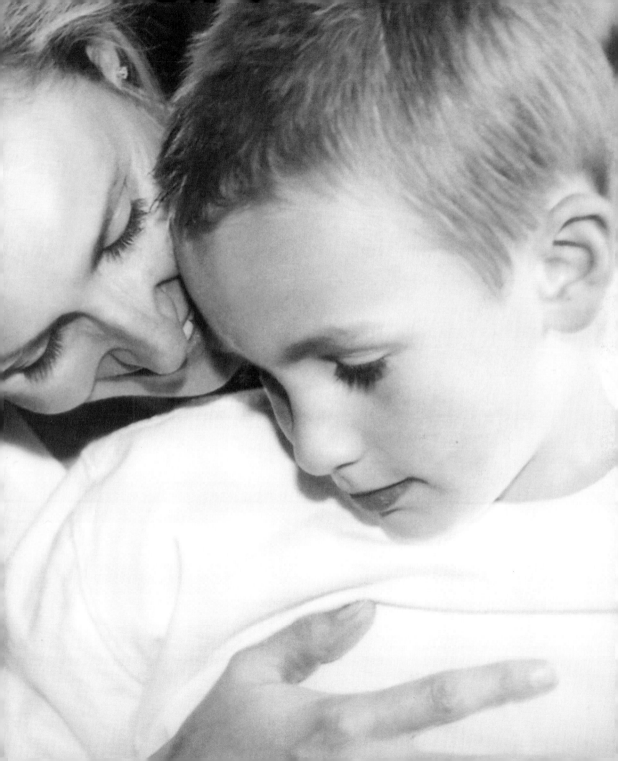

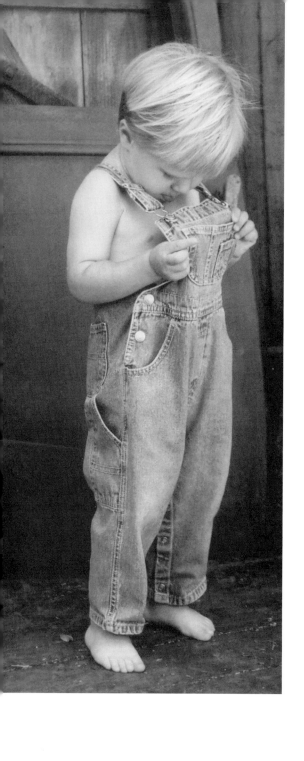
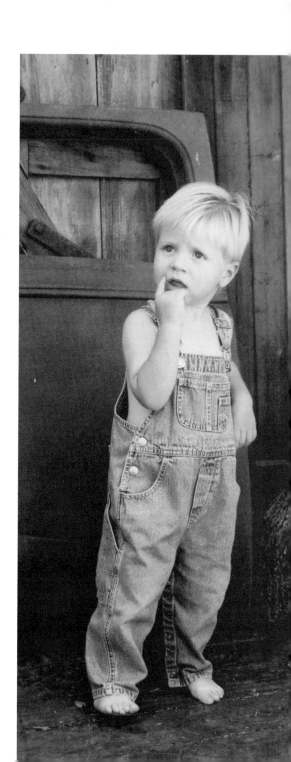

When you're curious, you find lots of interesting things to do.

[WALT DISNEY]

Old age lives minutes slowly,
hours quickly;
childhood chews hours
and swallows minutes.

[MALCOLM DE CHAZAL]

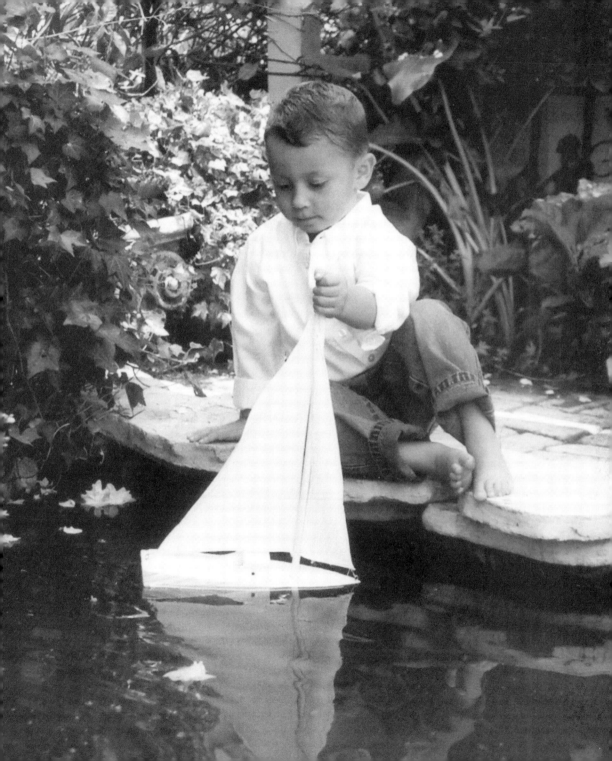

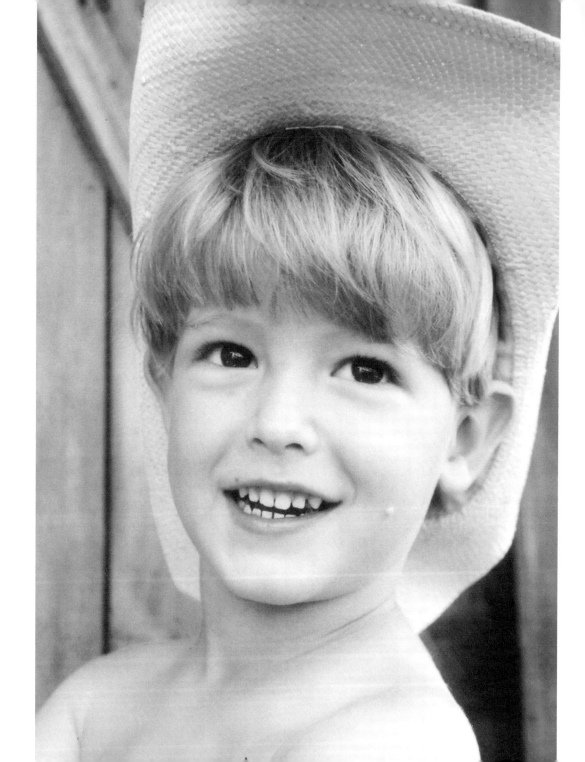

Cowboy hats

Pony rides

Making huts

Places to hide

Shiny pennies

Treasured toys

Pockets filled

He's a BOY!

[UNKNOWN]

There are only two things a child will share willingly:
communicable diseases and
his mother's age.

[DR. SPOCK]

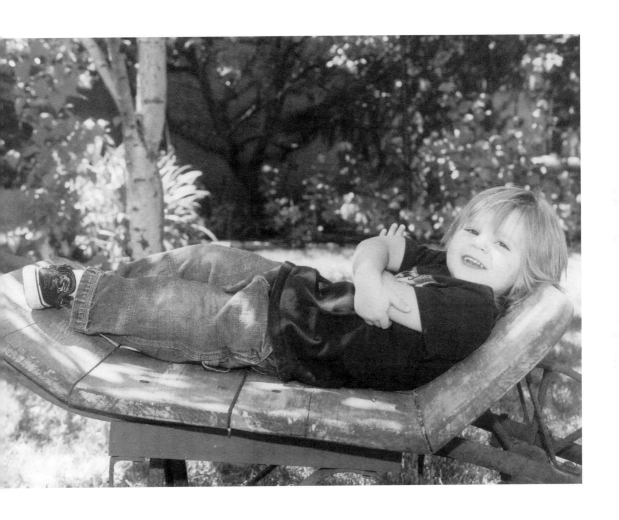

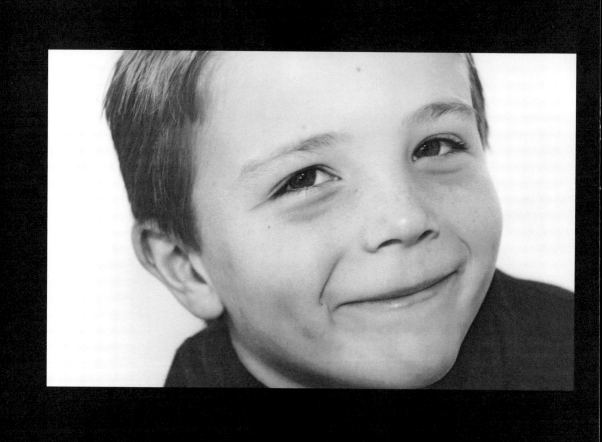

There's nothing that can help you understand your beliefs more than trying to explain them to an inquisitive child.

[FRANK A. CLARK]

When I was a boy, I used to do what my father wanted.
Now I have to do what my boy wants.
My problem is: When am I going to do what I want?

[SAM LEVENSON]

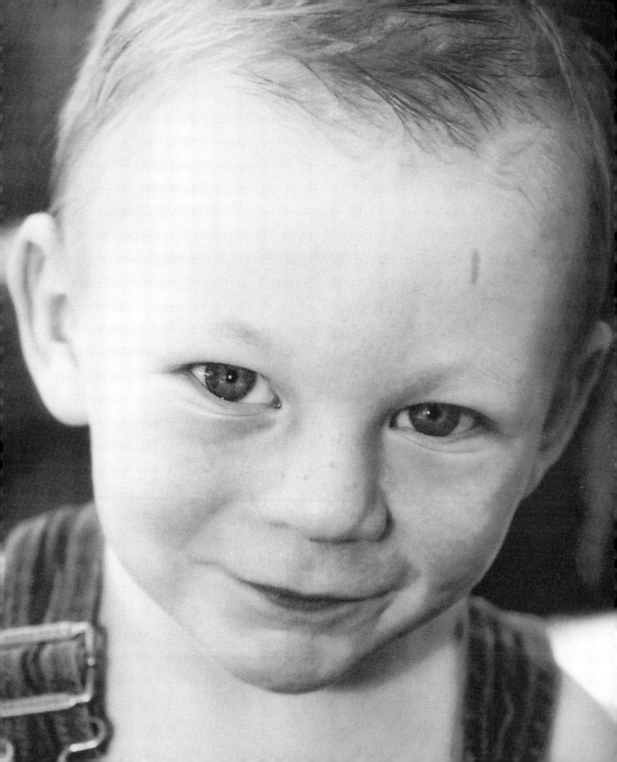

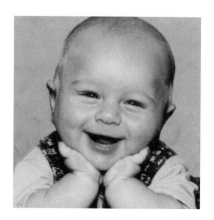

How did it get so late so soon? It's night before it's afternoon. December is here before it is June. My goodness how the time has flewn. How did it get so late so soon?

[DR. SEUSS]

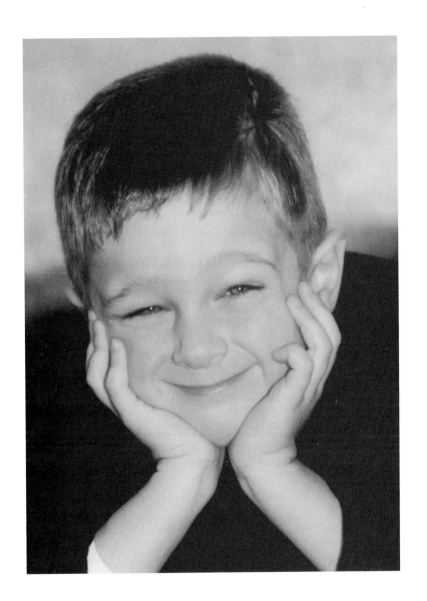

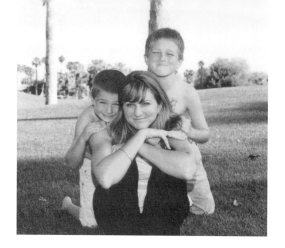

About the Author

Karen Henrich has been photographing children and their families for over a decade. Her goal is simple: to capture the unique soul of each child she photographs. Each child is different, and keeping that as a focus, Karen photographs children as they explore the park-like setting of her garden studio without a lot of direction. She believes that each child will show their wonderment with the world through their actions as she captures them through the lens.

Karen lives in Northern California with her three boys—her husband, Scott, and two boys, Chris and Mason—and her only girl, an English bulldog named Jezebel.